Picture It with Beans

Instruction Manual

Picture It with Beans
Joan L. Harrison

Copyright © 2019 Joan L. Harrison

All rights reserved. No part of this publication may be reproduced, distributed, or transmitted in any form or by any means, including
photocopying, recording, or other electronic or mechanical methods, without the prior written permission of the publisher, except in the
case of brief quotations embodied in critical reviews and certain other noncommercial uses permitted by copyright law. For permission requests, write to the publisher, addressed "Attention: Permissions Coordinator," at the address below.

ISBN: 9781079374629

Any references to historical events, real people, or real places are used fictitiously. Names, characters, and places are products of the author's imagination.

Front cover image by Author
Book design by Author

Printed by Amazon KDP Publishing in the United States of America

First printing edition 2019

Amazon.com

www.jlhbeanbook@gmail.com

Dedication

This book is dedicated to Robin, my daughter. Without her insight and ability to value something that I had long forgotten, this book would not exist.

Acknowledgement

I wish to acknowledge first and foremost my Lord and Savior Jesus Christ. I take no credit for the talents that I have, God has graciously given me abilities beyond my understanding.

I thank my daughter, whom I have dedicated this book to, for her tireless efforts and hours spent in reading, editing and assisting me with creative ideas and suggestions during the creation of this book.

Many thanks to Howard by dear brother. I call Howard my hero, because he always comes to my rescue whenever I need help. All the photographs in this book were taken by my brother. He worked diligently to photograph every photo displayed in this book.

Forward

I have always had an interest in writing. Before I retired and was still working within the IT field, I wrote many short stories. Much of my writing during my career was technical, but in my spare time I wrote children's stories and poetry. Over the years I never lost my desire to write a book and I have always had a love for drawing and painting, as well as other arts and crafts. I really do not know why, 30 years ago, I chose beans as a media for creative expression. I believe it was because I always bought dry beans and cooked them for my family. One day I looked at the beans and could visualize them in a picture.

I created my first bean picture in 1983. The beans in the picture are still just as beautiful as they were when I created the picture 35 years ago. This says a lot about the durability of beans. As I looked at that picture, I was reminded that beans have always been widely used as food, and they are also used to make many items that we use in our daily lives, but rarely are they used to create beautiful pictures. I felt that this could be because there are no instructions or manuals on how to perform this craft. Hence, this book, "Picture It with Beans" was born.

Contents

Introduction	1
Using Beans in Arts and Craft	2
Did You Know	3
Section 1 - A Picture Is Worth A 1000 Beans	3
Caribbean Lady	3
Centerpiece	4
Mother and Child	5
Fruit Bowl	6
Mother and Child – 1983	7
Floral	8
Black Bird	9
Section 2 - Tools and Materials	10
What You Will Need	10
Section 3 - Types of Beans	9
Choosing Your Beans	9
Section 4 -Selecting a Subject	11
Types of Pictures to Use	11
Section 5 -Framing Your Picture	12
Choose Your Backing	13
Section 6 - Tracing	14
Backing Techniques	14
Section 7 - Gluing	16
Section 8 - Drying	17
Section 9 - Sealing	18
Section 10 - Storing Your Beans	18

Containers	18
Labels	19
Storage	19
Section 11 - Setting Up Your Workspace	**19**
Table	19
Towel/Wash Cloth	20
Paper Plates	20
Section 12 - Techniques and Tips	**21**
Cutting Beans	21
Lay then Glue	22
Take a Picture	23
Lifting Beans after Gluing	23
Sorting Beans	24
Beans to Use for Outline	25
Color and Texture	25
Section 13 – Safety	**26**
Using A Razor Knife, X-Acto Knife or Scissors	26
Handling Glass	27
Section 14 - Planning Your Project	**27**
Color Pencils/Gel Pens	28
STEP BY STEP INSTRUCTIONS	**29**
Section 15 - How to Prepare Picture Frame	**29**
STEP 1 – 8 ½ X 11 Picture Frame.	30
STEP 2 - Prepare the Picture Frame.	31
STEP 3 - Glue Glass to Backing.	32
STEP 4 - Glue Sketch to Glass.	33
STEP 5 - Assemble Picture Frame.	34

STEP 1 – Outline 36
STEP 2 – Pedals 37
STEP 3 – Leaves and Stem 38
STEP 4 – Outer Portion 39

Introduction

Beans are an excellent source of protein, fiber, manganese, magnesium, iron, zinc and potassium. They are also fat free and cholesterol free. It's not surprising that this healthy and nutritious food has been cultivated by humans for over 6,000 years. Beans come in a variety of sizes, shapes and colors. Because there are so many types of beans available, it's no wonder that in addition to being used for food, beans are also used for other purposes. For example; beans are used to make jewelry, furniture, toys, musical instruments, and are perfectly suited for use in arts and crafts. Heirloom beans which are speckled, spotted, red, black and white are a popular choice for making jewelry. People in Mexico, Haiti and Africa for example, as well as the United States and other countries, have been making jewelry with beans for many years.

Using Beans in Arts and Craft

There are many reasons why beans are a good choice for arts and crafts. First and foremost, beans are plentiful and can be purchased in a variety of stores. Beans are also inexpensive and can be easily stored for a long time. They are also very durable and can last for years without deteriorating. Bean pictures do not have to be painted. The beans provide all the color necessary to produce an attractive picture.

A list of beans to select from are shown in Section 3. However, do not limit yourself to these beans. Most beans can be used to create lovely pictures.

Because beans are so readily available and inexpensive, this is a craft that can be used in so many venues, and by people of all ages, both male and female. It's a fun craft for kids that can be used at home, in school, daycares and youth centers. This is a perfect craft for the elderly whether at home, in a nursing home, assisted living or a senior center. People who are handicap with limited mobility would also find this craft enjoyable.

When I decided to write this book, I felt I needed to do as much research as possible about beans. I wanted to learn all I could about the history of beans, and particularly how beans have been used in the past as well as today. I found some facts about beans that I did not know, and you may be surprised as well.

Did You Know

- Dry pinto beans are a more cost-effective form of protein then lean beef or chicken.

- There are approximately 71,089 people in the world with the last name Bean.

- Vermont, Montana followed by Wyoming rank the highest in searching for bean recipes.

- North Dakota still ranks the highest as a producer of dry edible beans in the United States.

- It is believed that 38.5 tons of baked beans are eaten in Britain every hour.

- There are over 13,000 varieties of beans worldwide.

- Today's beans are genetically very close to the beans that was eaten thousands of years ago.

- Cooked beans can be frozen for up to 6 months.

- It's recorded that in the 1980's, bean seeds found in a clay pot sealed with pine tar, believed to be 1,500 years old – grew when they were planted.

- The Navy bean got its name for being a prime food item in the galley of Naval ships in the 19th century.

- Kidney beans received their name because of their resemblance of our internal renal organs.

- The five top beans grown in the United States are Pinto Beans, Navy Beans, Red Beans, Black Beans and Great Northern Beans.

- The world's tallest Bean Plant was over 45 feet tall.

Walk with me through this book and I will show you how to make pictures with beans that you will find enjoyable, rewarding and proud to display. Making bean pictures can be as simple, or as complex as you want it to be. You do not have to be an artist or have a special skill to participate in this craft.

I hope you find this book both useful and enjoyable.

Section 1 - A Picture Is Worth A 1000 Beans

Caribbean Lady

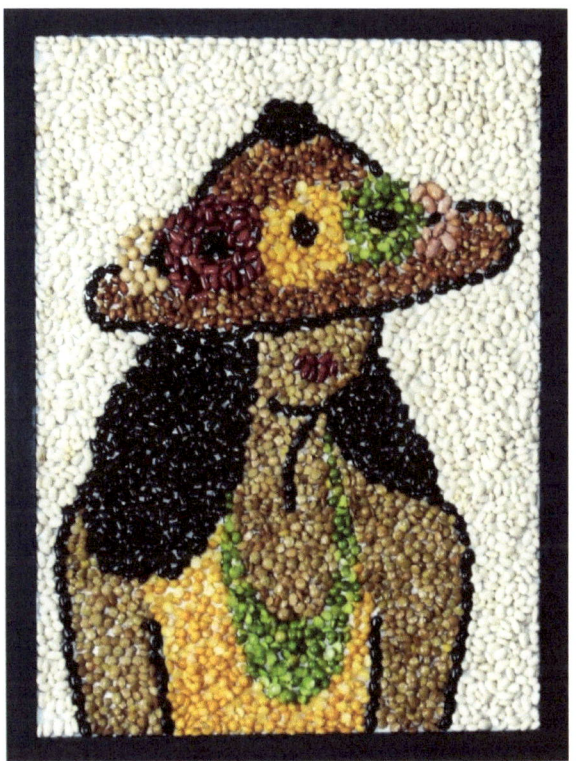

The Caribbean Lady was created using 8 type of beans; Navy Beans, Dark Red Kidney Beans, Black Beans, Pink Beans, Yellow Split Peas, Green Split Peas, Chick Peas, and Lentils.

Centerpiece

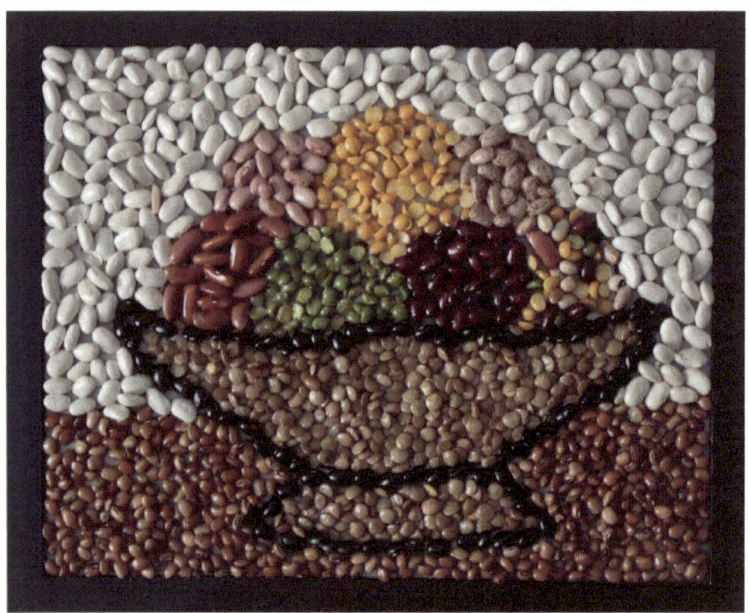

The Centerpiece was created using 11 type of beans; Navy Beans, Black Beans, Lentils, Cranberry Beans, Dark Red Kidney Beans, Light Red Kidney Beans, Pink Beans, Pinto Beans, Yellow Split Peas, Green Split Peas and mixed beans.

Mother and Child

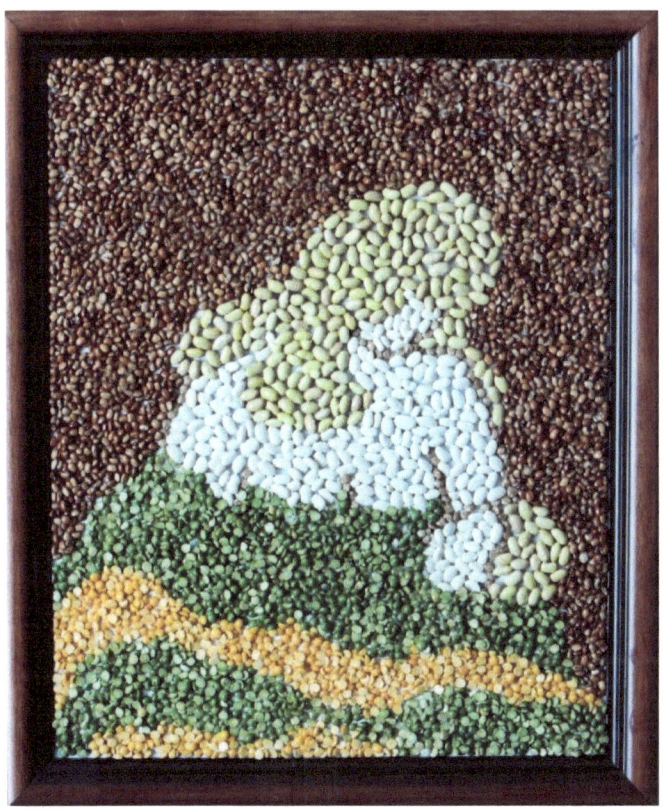

The Mother and Child was created using 6 type of beans; Navy Beans, Yellow Beans, Lentils, Yellow Split Peas and Green Split Peas and Small Cow Peas.

Fruit Bowl

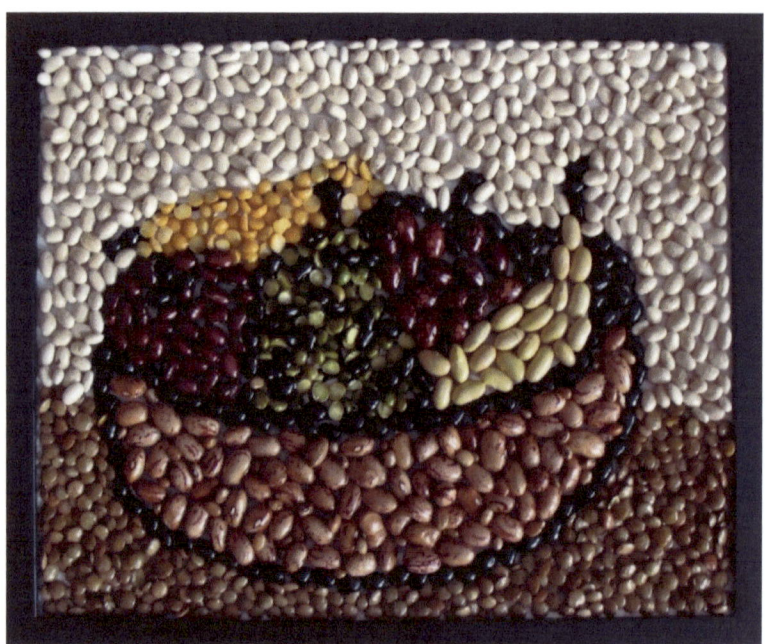

The Fruit Bowl was created using 9 type of beans; Black Beans, Yellow Split Peas, Canary Beans, Red Cranberry Beans, Green Split Peas, Red Kidney Beans, Large Cow Peas, Small Cow Peas and Navy Beans.

Mother and Child – 1983

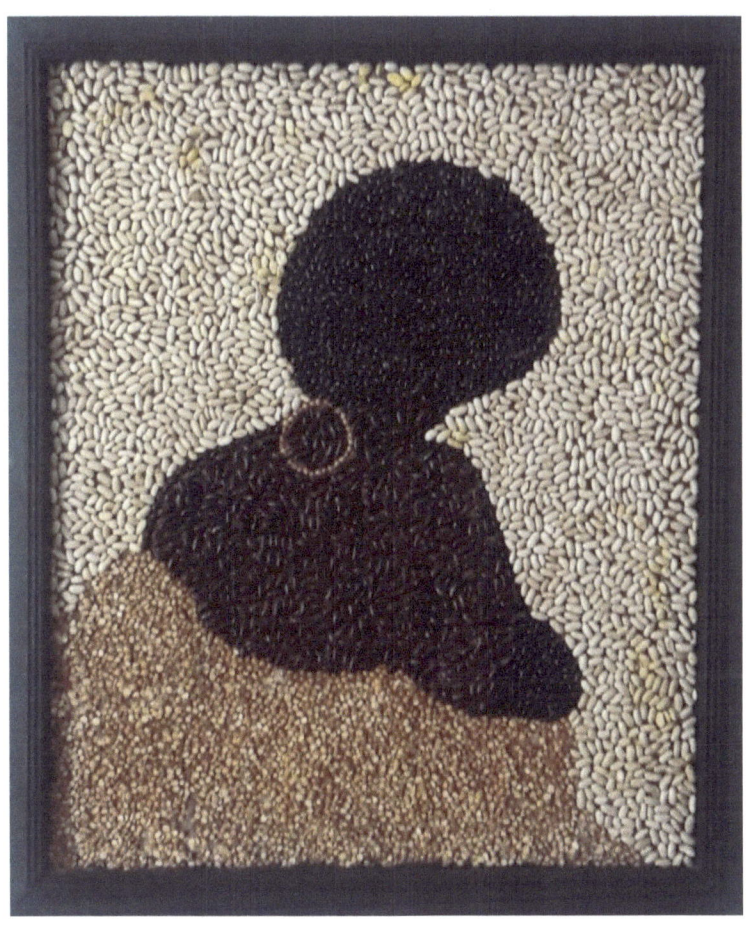

The Mother and Child was created using 4 type of beans; Great Northern Beans, Navy Beans, Black Beans, Dark Red Kidney Beans and Yellow Split Peas.

Floral

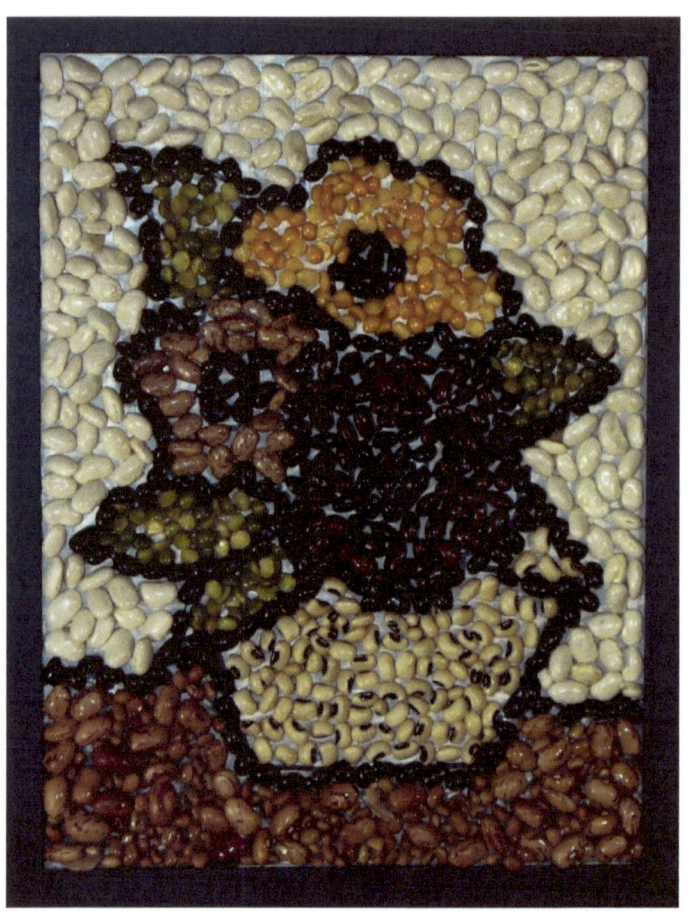

The Floral was created using 9 type of beans; Navy Beans, Black Beans, Dark Red Kidney Beans, Yellow Split Peas, Pinto Beans, Green Split Peas, Black Eye Peas, Large Cow Peas and Small Cow Peas.

Black Bird

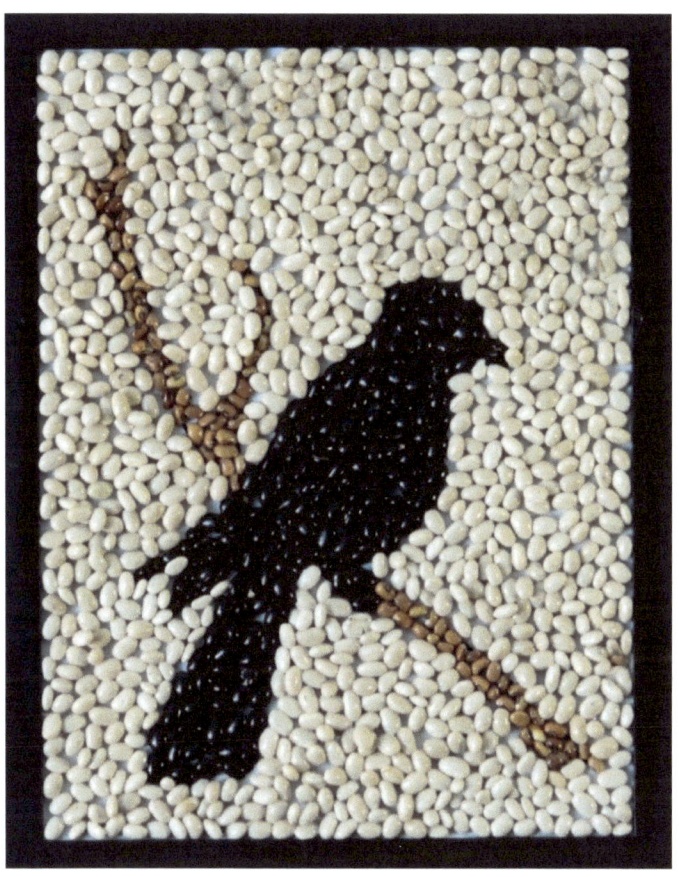

The Black Bird was created using 3 type of beans; Black Beans, Small Cow Peas and White Navy Beans.

Section 2 - Tools and Materials

What You Will Need

Any craft that you engage in will require specific material and tools if you expect to produce a successful product. If you are learning how to paint with oils, you will need various type of paint brushes, an easel, container for oil paint, turpentine, canvas, linseed oil, oil paints and maybe a palette knife. If you want to learn how to stain glass, some of the supplies you will need include; grinder, soldering iron, stained glass, glass cutter, breaker, pliers, copper foil, burnisher, flux, marking pen and safety glasses.

Bean pictures only require four items; picture frame, beans, glue and sealer. When I made my first bean picture over 30 years ago, I used white Elmer's glue. Today there are a variety of glues in several price ranges to choose from. If you don't like seeing the glue when making your picture, choose a clear glue.

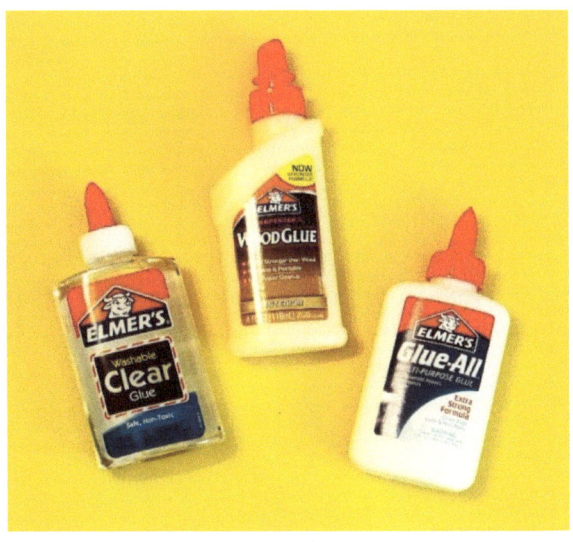

Wood is an excellent surface for gluing beans to. There are, however, other surfaces that can be used which also work well and should hold up for a long time. We will explore this more when we get to the section on framing. Proper gluing along with a sturdy backing will ensure that your bean picture holds up for many years. Beans are very durable – your picture could stay in tack for 25 years or more.

Always use a sealer when you finish your picture. The sealer will give your beans a polished look. The beans will glow and look radiant.

Tools you may also like to include would be a craft brush and a pair of tweezers. The brush will come in handy when applying glue. The tweezers can be used to position and move around beans without getting glue on your hands.

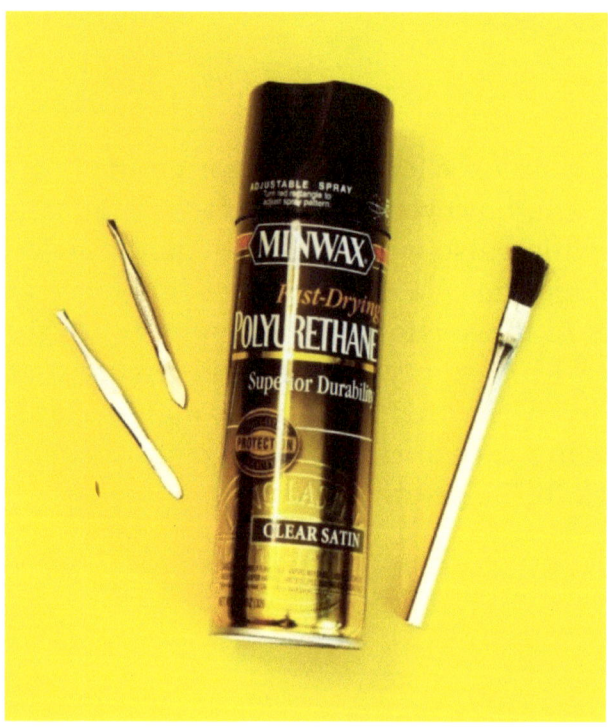

I am not a fan of borderless picture frames for bean pictures, but if that is your choice, try it and see how you like it. If you decide to use a picture frame I would suggest a frame that has a border, a backing and a glass/plexiglass cover. If the picture frame does not have glass/plexiglass, make sure the back of the frame is sturdy. If you don't want to hang your picture, you can select a table top picture frame.

Section 3 - Types of Beans

There are many types of beans that can be used to create beautiful pictures. These beans can be found in a variety of stores. You can purchase beans in supermarkets, variety stores, malls and pharmacies. How many beans you will need to purchase will depend on the size of the picture you wish to create. Do not limit yourself to the beans shown in this book. If you go to a specialty store and find some unusual beans that are not listed here, by all means - use them! Let your imagination run wild and use any beans you like.

Choosing Your Beans

The type of beans you will use depends on the type of picture you wish to create. The variety of the beans available can provide all the color you need. Beans come in a variety of sizes depending on the type of bean it is. Choose beans in different sizes that are the same color - for example, Great Northern Beans and Small White Beans. You will need an assortment of sizes to fill in the gaps between larger beans.

Here are some of the beans that you will be using for your bean pictures.

Dark Red Kidney Beans

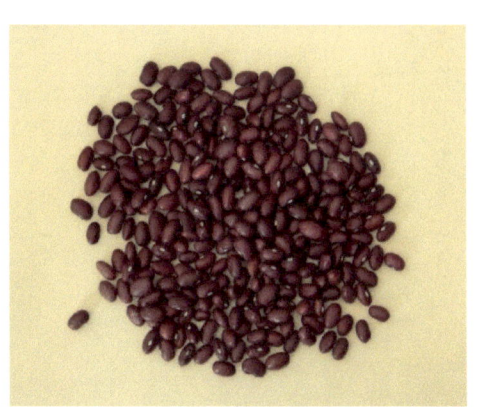

Small Cow Peas *Great Northern Beans*

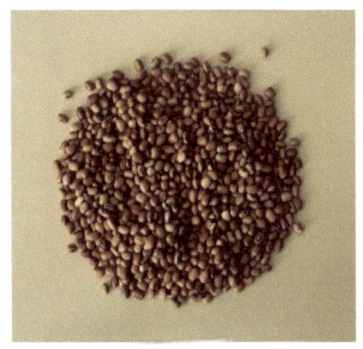 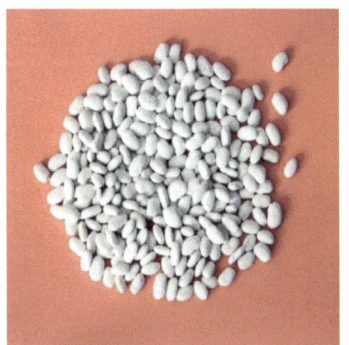

Lentils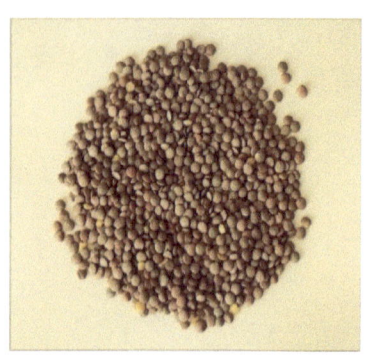

Black Beans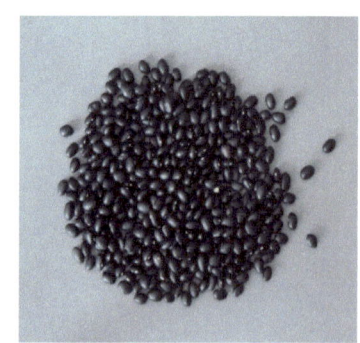

Red Cranberry Beans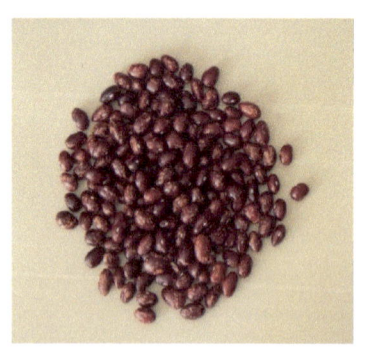

Large Cow Peas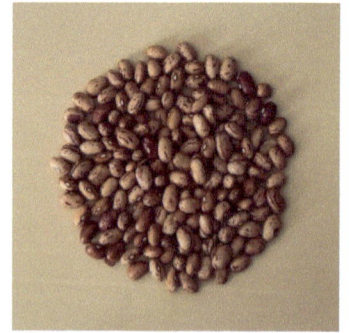

Yellow Split Peas

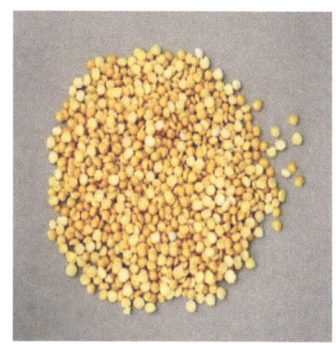

Green Split Peas

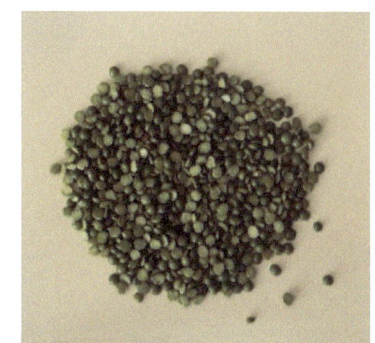

Small White Beans

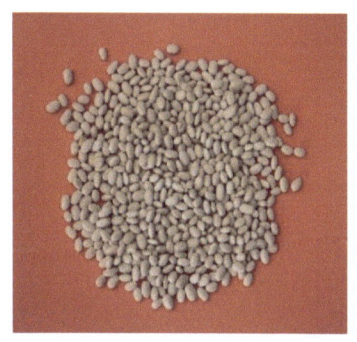

Light Red Kidney Beans

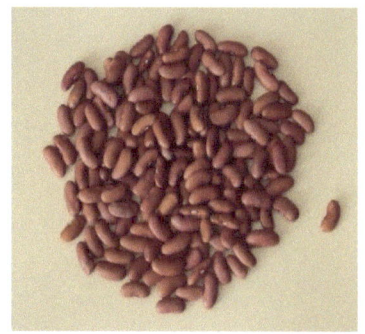

Small White Chick Peas

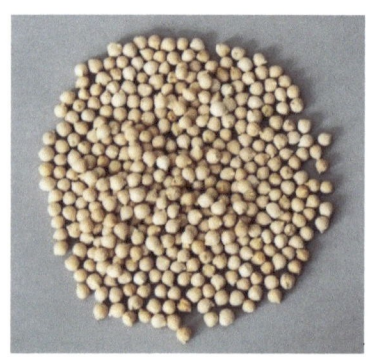

Canary Beans

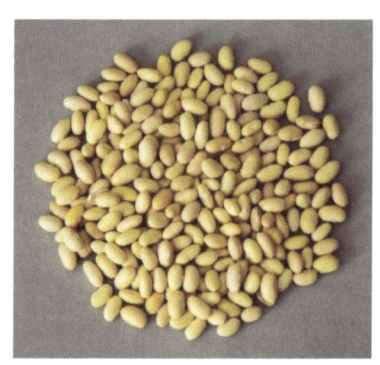

Large White Chick Peas

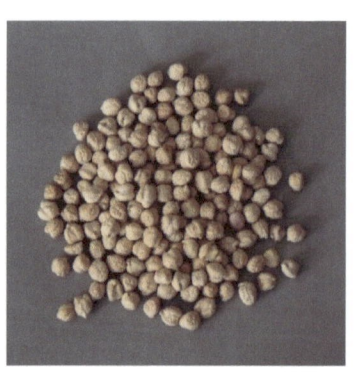

Pink Beans

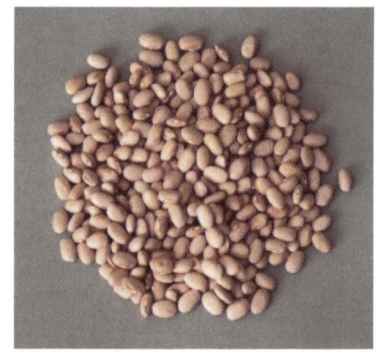

Navy Beans Pinto Beans

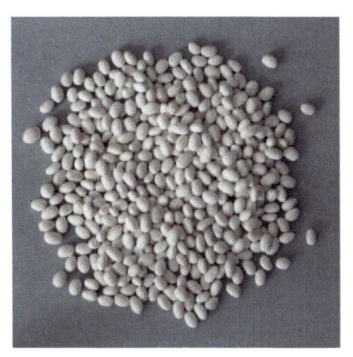
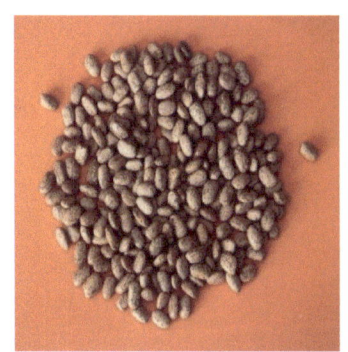

Black Eyed Peas

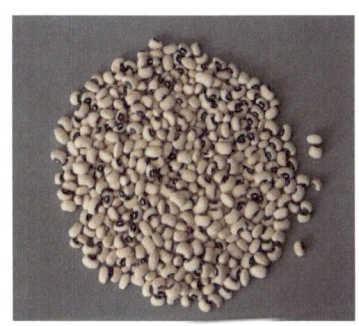

Section 4 - Selecting a Subject

Selecting a subject for your bean picture is probably the hardest part of this craft. Not all pictures are suitable for this craft. The most important thing to remember when selecting a picture is simplicity. Beans do not allow you to add the details and values that you see in paintings, drawings and photographs. Detailed pictures or pictures with many assorted colors may not yield the result that you would like when using beans because you will have a limited color pallet.

Types of Pictures to Use

Use pictures that have definable shapes such as circles, oval and squares.

Silhouettes are good subjects because they lack details and are featureless, which is appropriate for a bean picture because it's difficult to create details using beans. Select a silhouette in a subject you like, and let your imagination bring it alive with beans.

If you are an artist and know how to draw, you can produce your own picture.

If you need help in finding the right subject for your bean picture, try purchasing the "Picture It with Beans, Sketch Book". All the pictures in this book are 8 ½ x 11 black and white sketches that can be glued to the backing of your picture frame.

Section 5 - Framing Your Picture

The first thing I do when creating a bean picture is prepare a picture frame. You do not have to frame your bean picture. If you decide not to frame your picture, you can skip this section.

If you decide to frame your picture, the frame needs to be completely constructed and ready to hang before any beans are applied. The construction includes, attaching the wire for hanging the picture, as well as painting the frame if necessary. You do not want to prepare a picture frame after the beans have been applied. Any banging or nailing of the frame can cause the beans to loosen and fall out.

Picture frames can be expensive, so here are some tips on how you can keep the cost down. This is especially true if you are making your first bean picture. Look for picture frames in thrift or discount stores. You can find a variety of used picture frames in all types of materials, colors and sizes. Depending on the size of the frame you desire, you may pay as little as $2.00. In addition, most used frames still have the wire hangings attached. You may also be surprised at some of the backings in these frames. Make sure your picture frame has a sheet of glass to cover the picture. This sheet of glass may be used as a backing. A picture frame will greatly enhance your bean picture, and it will be something that you are proud to hang on your wall.

Choose Your Backing

You can use any frame you like, just make sure the backing is sturdy. The best backing to use is plywood, but any backing that is sturdy, that beans will adhere to can be used.

Plywood provides a very sturdy surface and you will be able to use any kind of glue and as much of it as desired to hold the beans in place. Your picture will hold up for a long, long time if you use this surface.

Avoid thin cardboard, or cloth canvas. These surfaces can be easily damaged when applying beans, or if the surface is exposed to moisture or water. If you are using a thin cardboard or canvas backing, pressing beans to fill in gaps, or pulling up beans after the glue has dried can cause the backing to rip. If you want to use the cardboard backing included with your picture frame, I will show you a very clever way of creating a sturdy backing using the glass from your picture frame – see **STEP BY STEP INSTRUCTIONS** in Section 15.

Section 6 - Tracing

Now that you have selected and prepared a frame, the picture you wish to create must be traced on the frame backing. How this is accomplished will depend on the size of the picture you want to create, and your level of artistic skill.

Backing Techniques

If you are creating a picture that is 8 1/2 x 11 you can make a copy of a sketch from the companion Sketch Book, which can be purchased separately. If you have a picture of your own that you wish to use, you can use tracing paper to transfer the image on the

backing. If you find a sketch that you would like to use, and want to make it larger or smaller than 8 1/2 X 11, and you are not an artist, you may have to use some type of picture tracer/enlarger to transfer a picture on to the backing in the size you desire.

If you don't have access to tracing paper, and you find a picture you want to use, you can cut it out, lay it on the backing and trace around the picture. When you are tracing try not to make your outline to thick or dark. You don't want it to show through after you apply your beans. The outline is just a guide to show you where to place your beans to create the picture you desire.

Some of you will be able to apply beans to form a picture without drawing a sketch on the backing. Since it will take time for the glue to completely dry, the beans can be moved around on the backing until the desired picture is achieved. This may not be a desirable method for the novice.

If this is your first bean picture, I would suggest you sketch, trace or glue the picture on the backing before you start applying the beans. This will help you produce the type of picture that you want to keep and will be proud to display.

Section 7 - Gluing

Today there are a variety of glues to choose from. Glues are designed to adhere to different surfaces. For example, if you are using a wood backing you may want to select one of the glues designed for gluing wood, but this is not necessary. The bean pictures shown in this book were made using Elmer's clear glue. Clear glue is excellent because it's transparent and does not interfere with the appearance of your picture during the process. After you have finished gluing your beans, spread clear glue over the entire picture for a stronger seal.

The only glue that you should not use is one that will adhere to the surface immediately. You want to be able to move around, squeeze and replace the beans during the gluing process. I would not suggest that you use a glue gun either. You may burn your fingers because the glue is very hot. The glue also dries very fast, and after the glue dries it is thick and noticeable to the eye.

Apply a liberal amount of glue to the backing, making sure that the outline of your picture remains visible so that you know where to place each type of bean as you form your picture. This is where a brush will come in handy. When you purchase your glue, you will usually find a brush for applying the glue in the same section.

It is during the gluing process that you may also find it useful to have a pair of tweezers handy. You can pick up a bean with your tweezer and place it between beans to fill in the gap, or use the tweezers to position your beans when making an outline on your picture.

Section 8 - Drying

When you have finished gluing your beans to create your bean picture, and you are satisfied that you have filled in all the gaps with beans, it is now time to let your picture dry. Drying time will vary depending on the size of your picture, and the amount of glue used under the beans and on top of the beans.

Allow your picture to sit for a few days, then test it by turning it over. If any of the beans fall out, replace them and apply more glue. If you don't apply glue to the top of the bean picture sometimes it's hard to tell if all the beans have been glued. I usually apply clear glue on top of my bean picture to ensure that no beans will fall out when I turn it over.

Section 9 - Sealing

When you are satisfied that your bean picture is completely dry and there are no loose beans, it is now time to seal your work of art. You will need a can of clear spray varnish. Spray the entire bean picture. Try to avoid getting varnish on your picture frame. After you spray your picture, the beans will glisten and look beautiful. How long it will take for your picture to set depends on how large your picture is and the type of glue you used. Once your picture is completely dry, it's ready to be hung.

Section 10 - Storing Your Beans

Containers

Beans should be stored in containers, not plastic bags. Containers allow you to see and sort through your beans when using them, plus containers are sturdier – you don't have to worry about bags bursting on you. Clear plastic containers are good choices because they allow you to see the beans. Containers also make setup easier when you are ready to begin working with the beans. All containers usually

have lids or some type of cover. You want your beans to remain dry and free from moisture.

Labels

Create labels for your containers or write on the containers. This is a good idea when storing Navy beans and Great Northern beans. Both these beans are white, and very similar in size and color. I have found Cranberry Beans that were very similar in size and color to Cow Peas.

Storage

If your beans are in a container with a lid, you can pretty much store them anywhere you like.

Section 11 - Setting Up Your Workspace

Table

You will need a table to work on. The table should be large enough to allow you to work on the bean picture you are making, and it should

have enough room to set up the materials and tools that you need to use. Your table should be able to hold your picture frame, all the beans you selected for your bean picture, glue, tweezers, and a wet towel/cloth.

Towel/Wash Cloth

You may find it helpful to keep a roll of paper towels handy for spills. I always keep a wet towel or wash cloth on my table. Even if you use tweezers, and I do, you will still get some glue on your fingers. If you don't have a wet towel or cloth to wipe the glue off, every bean you touch will stick to your fingers.

Paper Plates

Why paper plates? A paper plate will be helpful when you need to sort your beans. Another reason you may want to sort beans is to select beans of a certain size. This is particularly true when gluing beans in a small area of your picture. You might want to select small beans. Spreading them out on a paper plate will make this process easier.

Section 12 - Techniques and Tips

Cutting Beans

Beans can be cut with the right tools – see Section 13. I cut beans for all my pictures. When gluing beans, they will always leave gaps. The larger the bean the more gaps you will see. You can't always find beans small enough to fill the gaps, so it becomes necessary to cut the beans in half. Cutting beans is not something I would recommend for children. Do not allow children to use the tools that are needed for cutting beans. If you are working with children and they want to fill gaps in a picture, make sure an adult does the cutting.

Another way to fill in gaps is using the same bean in a smaller size. For example, Small White Beans can be used to fill in the gaps for Great Northern Beans or Navy Beans. Chick Peas and Cranberry Beans also come in two sizes. Medium beans and small beans. Try using both large and Small Cow Peas. They look good together, and you can fill in gaps easily.

Lay then Glue

One of the techniques I have used is some of my pictures is to lay my beans on the picture without any glue. This is when I am trying to decide what bean I want to use in a certain part of the picture. If I don't like the way the beans look, I can easily scoop the beans up and try another type of bean. Once I have decided on the beans I want to use and am satisfied with the way it looks, I spread the glue on top of the beans. The glue will seep down between the beans onto the backing as well as the top of the beans to seal the beans in place. Apply a liberal amount of glue on top of the beans when using this technique. After the glue dries, run your fingers over the beans. If any of the beans are still loose, they will move. You will need to apply more glue.

This technique does require more glue then normally used if the glue is applied first, but sometimes it's worth it. It's a little messy to have to remove beans that have glue all over them.

Take a Picture

Today, most of us have a cell phone, and most cell phones have a decent camera. I have found that taking a snapshot of my picture helps me to see what it really looks like. After you take a snapshot you will be able to see uneven outlines, whether certain beans work together and if you need to change something in your picture. 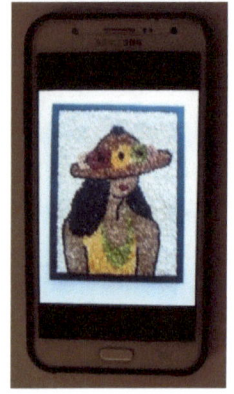 Take your snapshot right after you glue the beans, before they have a change to dry. After you review your snapshot you can make any changes you like to your picture. It will be easy to move the beans around or lift them off the picture if desired.

Lifting Beans after Gluing

Sometimes, even after taking a snapshot and looking at your picture, you are still not sure you like your work of art. You may not change your mind until a day or two later, and the glue has dried. It's still not too late. This is when your tweezers will come in handy. Use your tweezers to pry the beans out. It may look a little messy, but when you apply glue and reapply beans in the same area you will not see any flaws.

Sorting Beans

When I sort through my beans I always find broken and discolored beans in every batch. Don't discard beans with discolorations, they add character to your picture. Broken beans can fit into tight spaces. Sometimes I like to pick up a hand full of beans and drop them on the gluey surface, so it's helpful if I've sorted through the beans first and know what I am working with. I also like to sort my beans to separate the smaller ones from the larger ones. This helps me when I am trying to keep the shape of an object in a picture such as a flower or a leaf. Another reason to sort beans is to find the smallest beans when you are using Black Beans to outline a picture. There are times you may want to use smaller beans to make an outline such as a stem or a branch, and sometimes you want larger beans for your outline.

Beans to Use for Outline

I like to use Black Beans for my outlines, but I have also used other beans. Lentils, Small Cranberry Beans, and Cow Peas also work well when creating outlines in bean pictures. Since there is such a large variety of beans available, I am sure there are many other different types of beans that can be used for outlining.

Color and Texture

When you select a picture, think about the type and color of the beans you can use. For example, Green Split Peas are good for creating leaves. Black Beans, Lentils and Cow Peas are good for outlining and creating the appearance of hair. Great Northern Beans, Navy Beans, Canary Beans, Pink Beans, Dark Red Kidney Beans and Red Cranberry Beans work well for flowers. Beans are very beautiful in their natural color.

Section 13 – Safety

Using A Razor Knife, X-Acto Knife or Scissors

In Section 15 you were given techniques that can be used to facilitate the creation of your bean pictures. These techniques require the use of very sharp tools; a Razor knife, an X-Acto knife or Scissors. These tools should be handled very carefully by adults.

Never put these tools in the hands of a child.

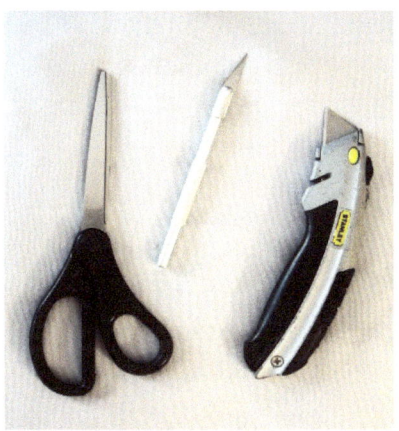

When children are permitted to make bean pictures they should be old enough to know that dry beans are not edible, and only adults are permitted to cut beans in half.

Handling Glass

In Section 15, I illustrate a clever technique for preparing your picture frame with a sturdy backing. This technique requires the use of the glass cover that most new and some pre-used picture frames have. This might be a technique that should be done by adults to ensure that the glass is not broken by pressing to hard when gluing the backing and the sketch on the glass.

This process does not require a lot of pressure. If an ample amount of glue is applied to the backing, the glass will stick to it without a lot of pressure. The same thing applies for the sketch. When the glue is applied to the glass, lay the sketch on top, and gently rub the top of the sketch with a paper towel to smooth out any bumps or creases.

Section 14 - Planning Your Project

When you are engaged in a craft, whether its painting, stained glass, crocheting or quilting you need a plan. If you want your project to be successful, take the time to make sure you have everything you need to complete your project.

When making bean pictures, make sure you have enough of the beans you want to use for your picture, and enough glue to affix your beans. Planning however, can entail more than tools and materials. Deciding what you want your picture to look like requires some planning as well. For example, the "Sunflower" picture shown in the Step by Step Instructions in Section 15 could have been created with Yellow Split Peas instead of Canary Beans. and the leaves could have been made with Small Cow Peas instead of Green Split Peas. The background could have been Cranberry Beans with an outline done using Lentils. The outcome would have been very different from the picture produced for this book.

This is your bean picture, so let it reflect your style and creativity. Remember, there is no right or wrong way to create your work of art.

Color Pencils/Gel Pens

If you are working with a sketch, make a second copy of the sketch. Try using colored pencils or gel pens to simulate the picture you want to create. Pick colors that are close to the color of the beans you are going to use. You can also use a black colored pencil or pen to simulate Black Beans that represent an outline. This will give you a pretty good idea of what your finished product will look like.

STEP BY STEP INSTRUCTIONS

Section 15 - How to Prepare Picture Frame

Most picture frames you buy, new or used, will have a sheet of glass to protect the painting, as well as a piece of cardboard for the backing. If the frame is new, it should also have a sheet of paper with a picture or a design that you can see through the glass. The other side of that sheet of paper is usually white. You can use the white side of the piece of paper to trace your sketch or replace it with a copy of your picture. If you wish to create a picture that is larger or smaller than 8 1/2 x 11, review the Tracing instructions in Section 6.

The following steps will show you how to prepare your picture

STEP 1 – 8 ½ X 11 Picture Frame.

STEP 2 - Prepare the Picture Frame.

Open frame and remove cover page.

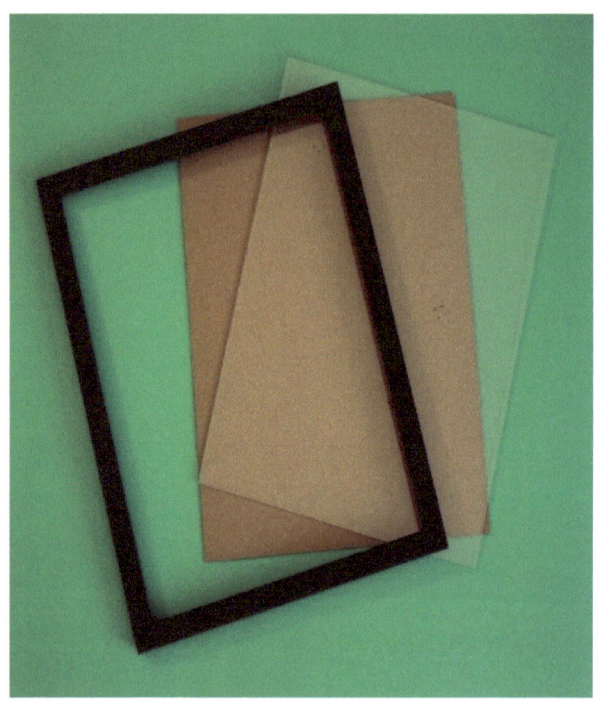

STEP 3 - Glue Glass to Backing.

Apply a liberal amount of glue to the backing, then lay the glass on top.

STEP 4 - Glue Sketch to Glass.

Apply a liberal amount of glue to the glass, then lay the sketch on top. Use a paper towel to rub across the top of sketch to smooth it out.

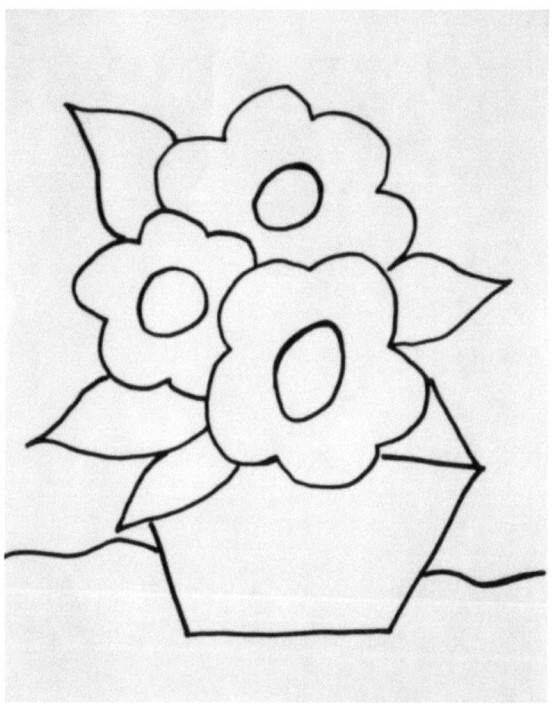

STEP 5 - Assemble Picture Frame.

Now place the backing back into the frame. You now have a sturdy backing for your bean picture. Attach wire for hanging if needed.

If the picture frame is pre-used, it probably will not have a sheet of paper to work with. You will have to remove the picture or painting in the frame and replace it with a copy of the bean picture you wish to create.

If you are not happy with the frame you chose for your picture, it can be removed and replaced after the picture is completed and completely dry.

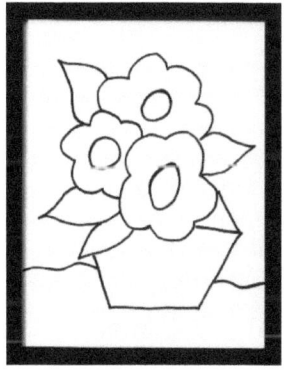

Section 16 - How to Make the Sunflower

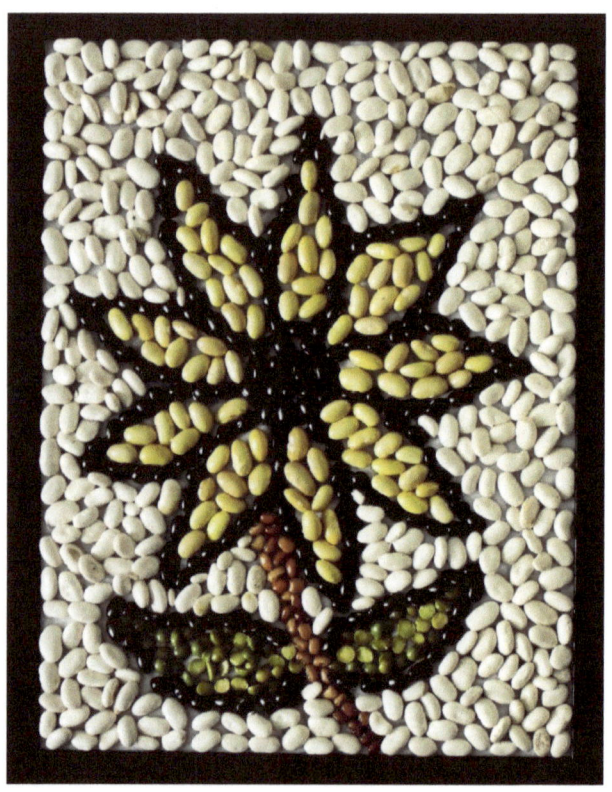

To make the Sunflower you will need Black Beans, Canary Beans, Small Cow Peas, Green Split Peas, Navy Beans or Great Northern Beans.

STEP 1 – Outline

Apply a liberal amount of glue on the outline of the flower, leaves and center of the flower. Lay the black beans on the outline. Fill the center of the Sunflower with black beans. Do not spread glue over the entire sketch because it will be messy when trying to apply the beans on the outline and other parts of the picture.

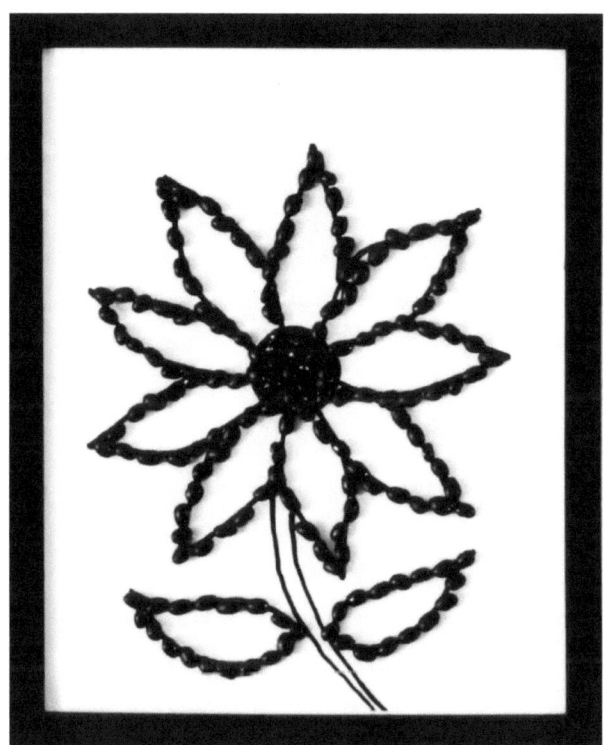

STEP 2 – Pedals

Apply glue in each flower pedal and Fill flower pedals with Canary Beans.

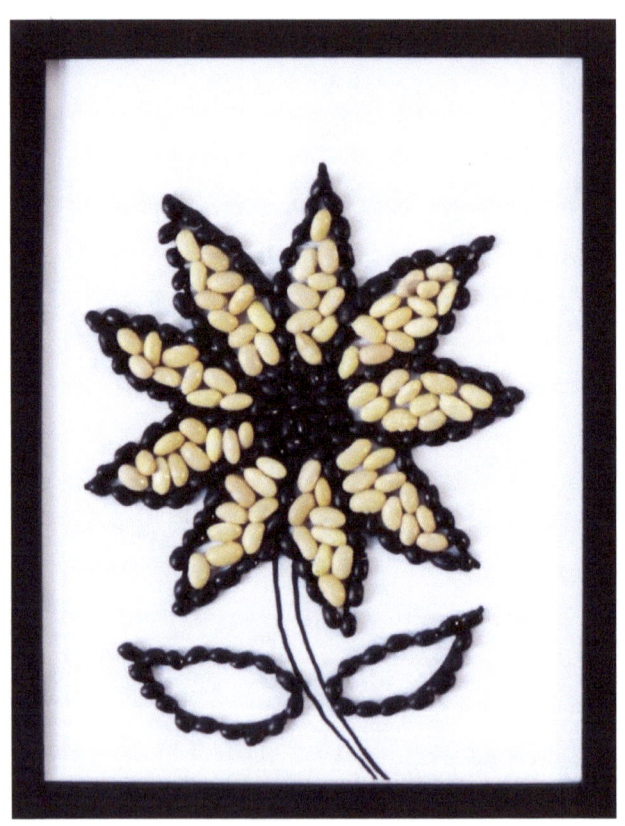

STEP 3 – Leaves and Stem

Apply glue in center of each leaf and in stem of flower. Fill the leaves with Green Split Peas. Fill the stem with Small Cow Peas.

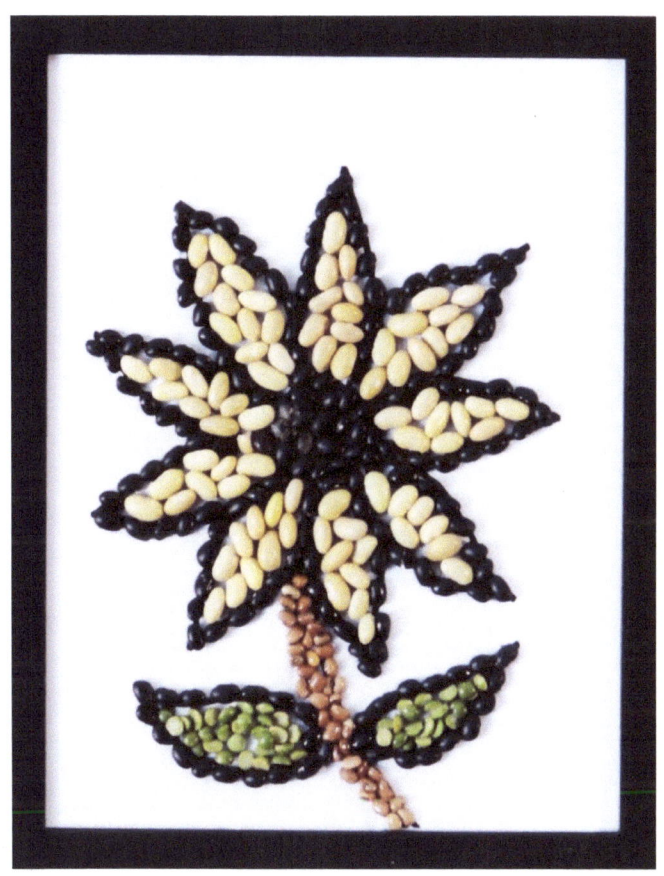

STEP 4 – Outer Portion

This is the final step. *Apply a liberal amount of glue around the entire flower. Fill the outer portion with Navy Beans or Great Northern Beans. Use Small White Beans or cut beans in half to fill in the gaps.*

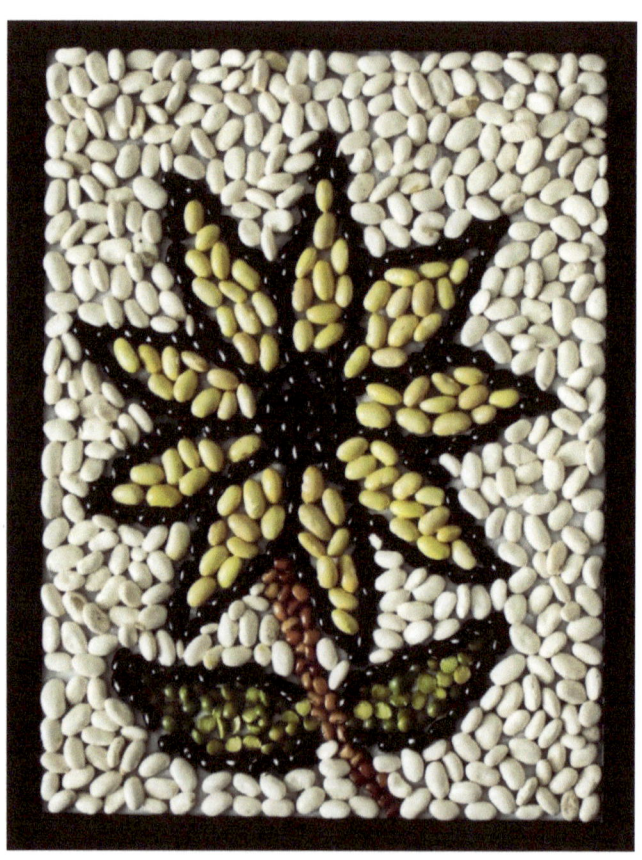

BIBLIOGRAPHY

Web Sites

http://www.americanbean.org/bean-facts/

http://www.extension.tennessee.edu/Smith/Documents/FCS/NFS2.%20Beans%20Lesson.pdf

http://www.mobile-cuisine.com/did-you-know/bean-fun-facts/

http://www.randallbeans.com/2017/01/05/5-fun-bean-facts-celebrating-national-bean-day/

AUTHOR BIO

Joan L. Harrison resides in Raleigh, NC. She is the mother of three and the grandmother of seven. Joan is a multi-talented artist/crafter of many years. She paints in acrylic and watercolors, writes poetry, quilts, crochets and sews. Her poetry appeared in several magazines and one of her poems received an award. Many years ago, Joan was inspired to use beans as a creative media. She produced her first 24 x 29 bean picture which hung upstairs on her mother's wall for over 30 years. After her mother's passing, she retrieved the bean picture and was amazed at the longevity of beans. Joan began making bean pictures again and wanted to share this craft with other people. Hence the creation of the "Picture It with Beans, Instruction Manual", and "Picture It with Beans, Sketch Book".

NOTE:

The Picture It with Beans - Sketch Book is available in paperback. The Sketch Book is 8 ½ x 11 and contains 25 sketches, including most of the sketches for the bean pictures shown in this book.

CONTACT INFORMATION:

www.jlhbeanbook@gmail.com

www.ingramcontent.com/pod-product-compliance
Lightning Source LLC
Chambersburg PA
CBHW041107180526
45172CB00001B/148